# Eventually My Past

Kaela Matthews

*Eventually My Past* copyright © 2020 by Kaela Matthews

All rights reserved. No part of this book may be reproduced or used in any manner without written permission of the copyright owner except for the use of quotations in a book review.

Illustrations, photography, and cover design by Kaela Matthews

single or taken?
dead or alive?
for confirming the latter
of each question
I risk being mistaken
But you haven't
given me reason yet to
believe otherwise and
I survive solely on the
hope that I am yours
So only confirm,
don't deny

The spark between us didn't last long
enough to light the match

I left in search of home
but all the roads I took led me
back to the start,
only to find that there is
a new owner of your heart.

*Bathtub Blues*

I drag myself over to the bathroom
where I'll lay for hours in the tub like
a confined corpse in a tomb.
The water is scalding hot,
as though I'm soaking in a
steaming teapot,
and I wonder if I add in
sugar and cream,
will I taste sweeter than I seem?

I try to be delicately soft,
but my skin is a thorn that no one would
touch at any cost.
And inner beauty doesn't earn me a thing,
if I don't beam like the sun in the spring.
And loving you with all my heart,
got me nowhere since what you were
seeking first was breathtaking art.

"Beauty is only skin deep"
was a virtue you never bothered to keep
And I cannot easily shield myself
from the heartbreak of you
I'm always drowning in blue:
my feelings and tears,
now bathwater too.

I let these days
pass by quickly
because without you
in them they
have no use
for me

even your silence was well spoken

suddenly everyone became an artist
and I became no one

*The Artist*

She moves from one project to the next

like arts and crafts,
simply rough drafts,
all practice attempts at a greater work

mistakes
She makes them all with no hesitation
apathetic
She saves herself for a worthy creation

fully drained,
no beauty left to render
their time with Her is now expired

indifferent,
She brushes them aside,
never considers them loss

though who could blame Her when
they were only scrap material?

and now She lays eyes on me,
Her latest project,
the process now reset

Her bittersweet strokes
across my fragile canvas,
i pray each is everlasting

but mistakes,
She begins to make with no hesitation
and apathetic,
She decides to save Herself for a worthy creation

and i am left to wonder
why wasn't i Her masterpiece?

the poems that I have not touched
since I last was touched
will remain
unwritten

You brought me into a game of no rules,
no labels, no nothings.
A game where I only know what we aren't,
 never what we are.
Where we exist together in ways that you
 tell me mean nothing
  because it can't mean something.
You say this game is a simple one,
 so it doesn't need an explanation.
But I've been playing long enough now,
 and I've begun to despise the system
 you've set up for the two of us.
If things are fine as you say they are,
 then why am I in agonizing pain?
Loving you is just a twisted game
 that I can never win,
  if there are no rules.

poems about you are born to be forgotten

If you told me that your heart was breaking,
I'd offer you mine for the taking.
I'd refuse to live another day
If it meant you wouldn't slowly slip away.
And if you told me I was the one causing your pain
I'd turn back the clock,
to the moment I first approached you,
but this time, I'd refrain.
To live alone yet still know of you,
Is something I would quickly opt to do.
If it would shield you from my frenzies of destruction,
I would reverse our initial introduction.
But if I told you that I was the one hurting,
And that how you treat me is disconcerting,
Would you do just as I have promised to?

You hold us like a seed in your
hand and expect us to blossom but
You can't have what you want if
you don't give another what they
need

I perceive myself as greedy,
but I always give so freely.
I never ask for my fair share,
only for a sign that you care.

I've stayed forever,
holding onto almost nothing
because it is, at least,
something

There's always something to fix
Something in me is always broken
I care too much for those who
have earned nothing
and don't care enough
for those who have
earned something.

A drop of rain or a hurricane
I only feel in extremes
But no matter the weather,
I only feel it for you.

you didn't notice it happening
before it was too late
the smiles she aimed at you
were bewitchingly fake
she wore the holiness of heaven
to mask her sins
so you let her lips dance lightly
all over your delicate skin
gazing into her eyes,
you fall into a sea of tranquilities
but underneath her contacts
are orbs of scarlet iniquities
you thought you loved a woman
so delicate, so pure, so light
but you have fallen in love
with the devil and she has
the deadliest bite

*Blackhole*

Your heart shuts out the light
While searching for a way in,
I made myself less bright
Like a star approaching
a black hole,
I was ripped apart
But black holes were stars
once too, before they
resembled your heart

this thunderstorm emerged from deep within my shattering heart, as though you had touched me like a lightning bolt strikes an electrically charged heart. the grief comes because I know all too well, you never strike the same heart twice, you only come to unleash hell

I called you love
and you replied there
existed no such thing

I dream every night in black and white,
stuck on default
Lately I haven't lived a moment in color
behind my closed eyes
Before you, my fantasies were lilac,
jade, and cobalt
Now with you in my bed,
I use hues of gray to conceive a sunrise
The memory of color fades
the longer you're in my head

you've become addicted to using
"we're gonna be okay"
as your chaser so reality doesn't
burn quite as badly
but I've been sober every time
you shouted intoxicated
vulgarities at me,
and hearing
"we're gonna be okay"
afterwards doesn't quite
soothe my pain

The storms you keep captive are raging to flee the forsaken cavity in your chest. And once they are unleashed, they will replicate the same corrosion inside me, but I am to blame for not running to safety sooner despite knowing how swiftly your storms progress

I felt myself decomposing in your arms
When I looked up to give you a kiss,
I saw blue lips, already weeks decayed

CAUTION
FALLING
ROCK

Your clock hand hit nine
and somewhere out west
the sun left us to set
Your knuckles hit me
one, two, three times
The other hand grips
a lit cigarette
At night I fear so much
could be lost
so stay with me a little
while longer
I'll pay any cost

stiff thoughts
and rigid bones
exhausted of
muggy mornings
and endless roads

i don't think i'll be
back another time
i drove too far
for a love that
wasn't mine

i promise you can tell me anything except for how you feel

you wouldn't notice me leaving
this is why I must

I shatter every last piece of myself
and divide me up to last a lifetime,
delicately place my parts in your hands,
each day, witness you violently throw
them all away
but I shattered every last piece of myself
to spend a lifetime giving them all to you
now they are useless to me
and I am useless to you.

Oh, it all went terribly wrong.
I never realized how broken I was
until I tried fixing you

my heart wanders through the
graveyard of past loves,
praying one will resurrect

happiness is homicide
for saturnine souls:
for them, their pain is pleasure

my veins are licorice candy,
strands thick with eleemosynary
supply of blood red brandy
flowing to feed a parasitic appetite
you suck me dry, soul leecher,
but I transfuse to you with delight

*I Love You*

the line goes nearly silent,
light sounds of muffled breath
from your end and I worry
what's to come
you always have something
to say and sometimes your
words aren't the softest and
sometimes I'd prefer you silent
but now you are and this is
foreign but I catch something
familiar in your silence
it's the sadness
it's seeping out from the
safety of your head and
into the world that you've
only known to be unforgiving
the silence is broken by a soft whimper
that is broken by wails so
loud and so long
I can't be sure if I am hearing them
through the phone or from states away
oh I wish I wasn't miles away
I wish I could hold you tight the way
your mom should have but never did
but all I can do is sit on the
other end of the line and
tell you everything will be alright
but how can you believe me when life
has shown you it won't
and that love is only for
those who aren't broken
the way you are tonight.

*As Long As We Both Shall Live*

this morning, in your kitchen,
your clumsy hands knocked a glass
of water onto me and I got just
as soaked as last night in your shower
when we lathered each other in
bubbles and soap,
wiping away the harshness of
the world to give ourselves a clean slate.
I am happy when your clumsy hands
make a mess, because we can hide
away from the world,
for just one moment,
and clean each other up.

this morning, in your kitchen,
your tired hands knocked a glass
of water onto me and I got just
as soaked as last night when a
stream of slander gushed
out from your mouth and drenched
me in sorrow. I jerk my arm to reach
for a towel to dry myself off, "i'm fine babe,
it's only water"

Your drinking habits stopped no
quicker than your swinging fists

words that cascade from your
mouth sting more than the
kisses from your nicotine laced lips

*at the sight of blood*

half a million gashes,
hidden underneath my surface
all from the jagged words of yours
i swallowed

i kept things spotless on the outside
because if the mess was left on display
for others to see, I knew more slices
followed

*Bloodthirsty*

my fresh lesions soak in each drop
of my summertime sweat
but I don't care to the ache
i need to [must!] clean You off first,
You're my priority
[i won't forget!]
my viscous blood runs
down the side of Your sticky
sweaty palms-
a thick strawberry concoction-
my gelatinous guts glisten on You
[i will clean!]
i stick You with a straw
and sip You like a bittersweet
milkshake of toxins
You are my first priority,
[incessantly!]
and now spotless,
You pulled off this
summertime
homicide
successfully

come back to the grave site
look again at that ghastly scene
the postmortem photos taken that night
were quintessentially obscene

your spirit should plea retribution
for wounds inflicted that can and can't be seen
by postmortem photos of your summer execution
past nor present, your soul now exists in between

It's hard for me to say you let this happen
but I think you really did.
Don't pretend this news is anything shocking,
you were always complaining about what he did.
You said you'd get around to fencing in your property,
so he couldn't leave again.
But you never started working on it,
only kept blaming him.
He ran away all the time,
whenever he got the chance.
You chased him through the woods each time,
yet you never did build that fence.
And somehow it was always his fault,
including the day he ran onto the highway.
Now you complain there is a grave to dig;
I'm sure that is something you'll get around to doing someday.

the only pretty thing about you is the art you inspired

If I wrote my angels as demons,
would you call me a tortured soul?
If I wrote the truth of my feelings,
would you call my poem dull?

I'm crafting beautiful little lies
with each bat of my sky blue eyes
and you fall softly for each one like rain

but when you come crashing down to earth
you'll want to take my advice for all that it's worth
loving me will only ever cause you pain.

I know how tight your grip can get,
you don't need to prove it to me.
I know how scary letting go can be.
But if holding on is draining you each day,
it may be time to walk away.
Loosen your grip,
count to three.
Breathe in and out as you set it free.
Some things just weren't meant to be.

Stars send their light
miles from home so we can see
all of space was too confining
for their desire to be free

I woke up in a city that doesn't exist
and I'm hoping you'll follow me there

Am I wasting words on
what I felt instead of
what I feel?

*June*

some seasons of life are warmer than others. June embraced me, left kisses on my cheek, and lifted me. She taught me about who I was to become and why life was meant to be better than what it seemed. When she noticed I was becoming more content to be me, she said to try it on my own. But she'd pay me a visit each year after to see how much I've grown.

I look at myself now, mid-January and cold, and don't recognize this soul.

I've had a handful of good moments since then, but my memories quickly get old. These pictures don't look like current me. I look at myself now, and I don't see the same essence as what used to be. I've stolen my own identity and have done a poor job too. Everyone looks right through me. Was I ever truly happy in June?

If I could bend oxygen,
I would hold you close
and not fear asphyxiation

they never walk out empty handed.
number one kept my strength
which left me defenseless
against number two when
she came to pluck my
heart off my sleeve,
and you could say I was
naive for keeping it there
but number three just walked
out with my innocence,
so now I'm really feeling
exposed and bare.
Vulnerable to an attack
from future number four,
i don't think I believe
in love anymore.

we are all time travelers from our pasts
looking to save our futures

*Eventually My Past* is a debut poetry collection written by Kaela Matthews. Her earliest piece, "Blackhole", originated when she came into orbit with a cataclysmic connection. This poetry collection was formed through moments of maelstrom, distress, and isolation as she grapples to survive a seemingly interminable battle. Painful present experiences will eventually become past. But is it sorrowful to watch as sadness fades? Is some pain pleasurable to remember?